Glorify God through Color

Sharon "Sherry" Grove

WESTBOW
PRESS®
A DIVISION OF THOMAS NELSON
& ZONDERVAN

Scripture taken from the New King James Version. Copyright © 1979, 1980, 1982 by Thomas Nelson, Inc. Used by permission. All rights reserved.

Scripture quotations taken from the Holy Bible, New Living Translation, Copyright © 1996, 2004. Used by permission of Tyndale House Publishers, Inc., Wheaton, Illinois 60189. All rights reserved.

Good News Translation® (Today's English Version, Second Edition) Copyright © 1992 American Bible Society. All rights reserved.

WestBow Press books may be ordered through booksellers or by contacting:

WestBow Press
A Division of Thomas Nelson & Zondervan
1663 Liberty Drive
Bloomington, IN 47403
www.westbowpress.com
1 (866) 928-1240

Because of the dynamic nature of the Internet, any web addresses or links contained in this book may have changed since publication and may no longer be valid. The views expressed in this work are solely those of the author and do not necessarily reflect the views of the publisher, and the publisher hereby disclaims any responsibility for them.

Any people depicted in stock imagery provided by Thinkstock are models, and such images are being used for illustrative purposes only. Certain stock imagery © Thinkstock.

ISBN: 978-1-5127-2755-5 (sc)

Library of Congress Control Number: 2016900963

Print information available on the last page.

WestBow Press rev. date: 1/20/2016

Hello and blessings to you from me, Sherry Grove!!! Thank you for choosing my coloring book to further Glorify God Through Color. My desire is that you will be further edified in Christ Jesus as you use your creative talents to color in these pictures. These designs were inspired by the Holy Spirit. The Lord leads me through vision. Back in 1982, when I was recovering still from a serious head on collision that broke both legs as well as 20+ other bones in my body, I asked the Lord why He kept me alive when it would have been much simpler to die. He started showing me dance!! I realized that was His answer to my question as this vision persisted. I had to learn to walk again so thought me dancing was a bit far fetched. Well, all things are possible with God!! To make a very long and miraculous story short, I started a dance ministry in 1988 and continued to glorify Him through the dance until 2003. I still teach children at my church but now, at age 68 and 2 new knees, I'm limited in what I can do. However, the joy of creativity never left me and the knowledge that God uses creativity in us to glorify Him.

I've said all this to let you know that I've learned God uses the Creative Arts to further His gospel. The most important word for anyone to hear today is "JESUS". Many of my pictures are just that one word ~ "JESUS". I also incorporated my love of the Zentangle art form in these pictures.

Now, some practical hints as you color in your creations. I have purposely had one picture to one page (not picture on front and back) so that you can cut them out and frame them if you desire. They make lovely gifts!! You may want to put a sheet of paper behind each picture as you color with inks and magic markers. It could bleed through and ruin picture underneath. I've purposely made some of the pictures with white space so you can draw in any design you'd like to enhance the picture. You can also write in anything the picture may inspire in you. You can write in prayer requests. It's your book ~ use it to your edification, worship and joy!!

It doesn't have to be all solid color. You can use dots or lines to color in and shade. Let the Holy Spirit be creative through you!!

May you be blessed as you worship in color through this book. Blessings & love, Sherry

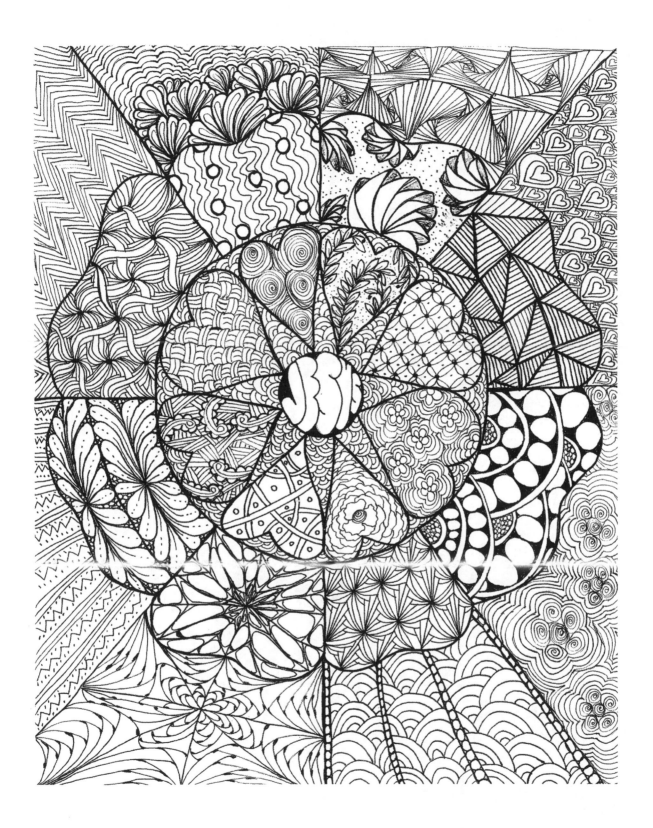

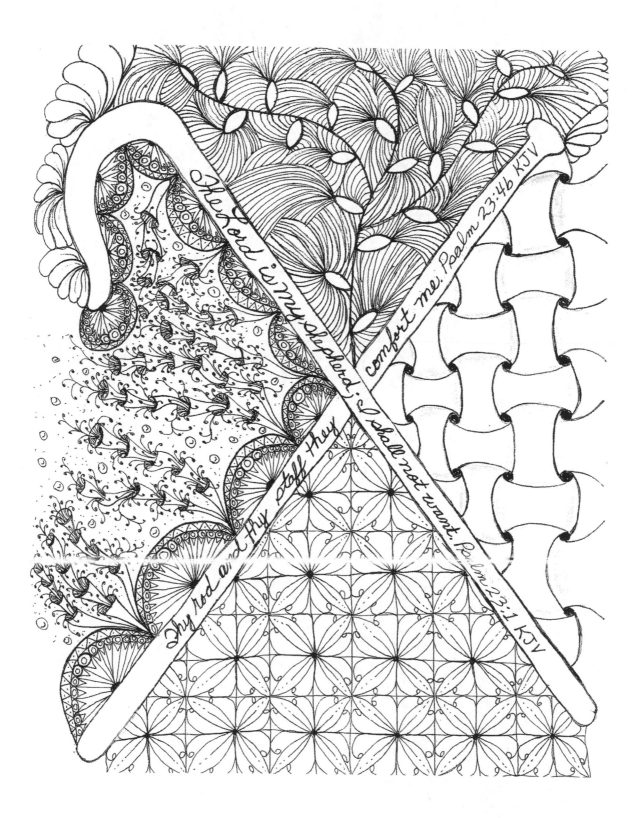

The Lord is my shepherd; I shall not want. Psalm 23:1 KJV

Thy rod and thy staff they comfort me. Psalm 23:4b KJV

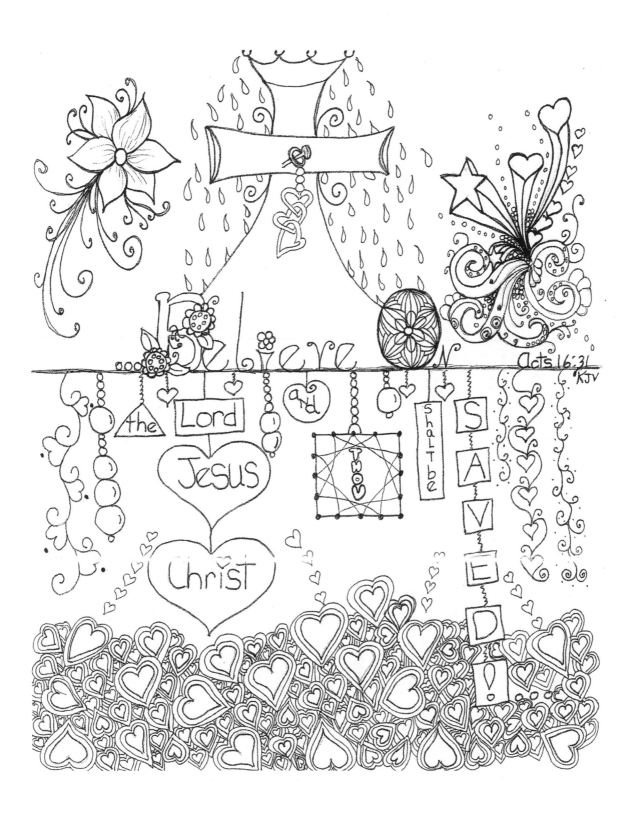

Believe on the Lord Jesus Christ and thou shalt be SAVED! Acts 16:31 KJV

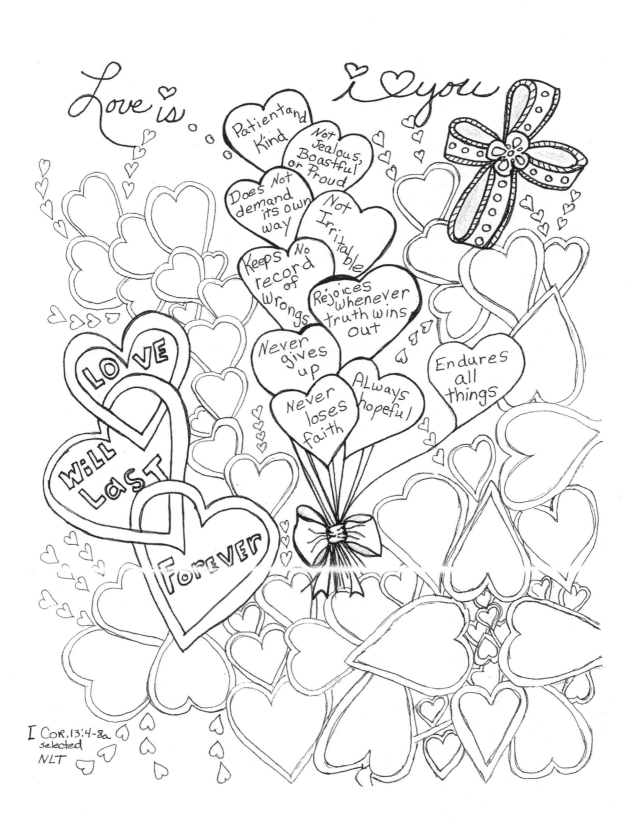

Love is...

i ♥ you

Patient and Kind

Not Jealous, Boastful or Proud

Does Not demand its own way

Not Irritable

Keeps No record of Wrongs

Rejoices whenever truth wins out

Never gives up

Endures all things

Never loses faith

Always hopeful

LOVE WILL Last Forever

I Cor. 13:4-8a
selected
NLT

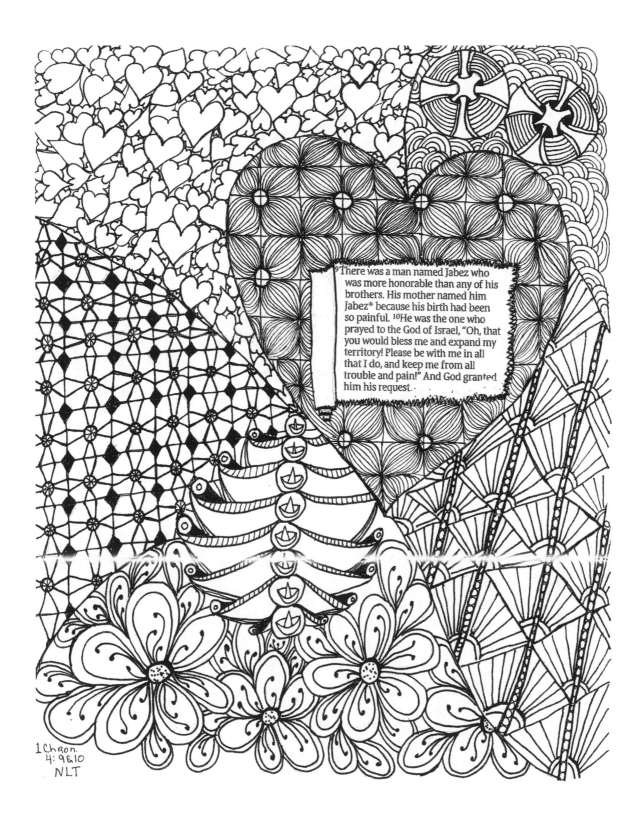

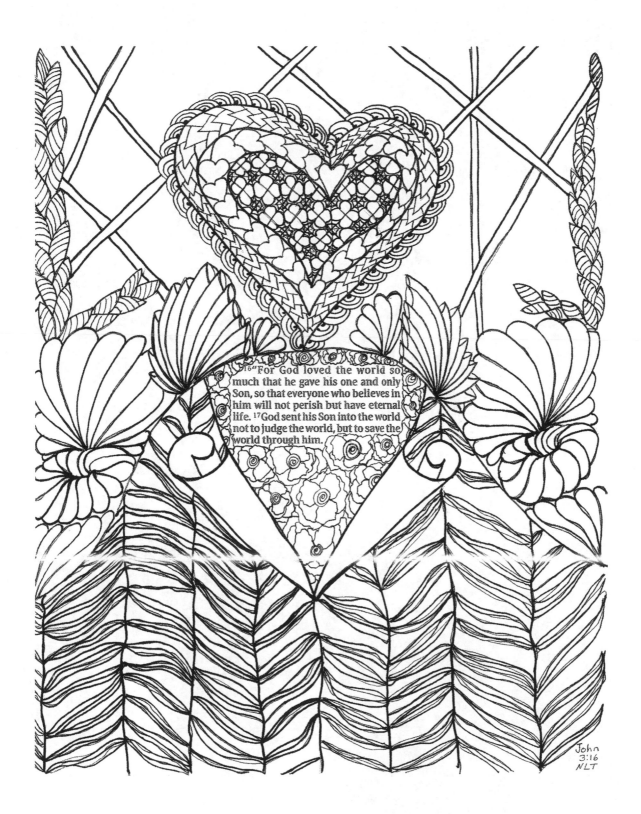

16"For God loved the world so much that he gave his one and only Son, so that everyone who believes in him will not perish but have eternal life. 17God sent his Son into the world not to judge the world, but to save the world through him.

John 3:16 NLT

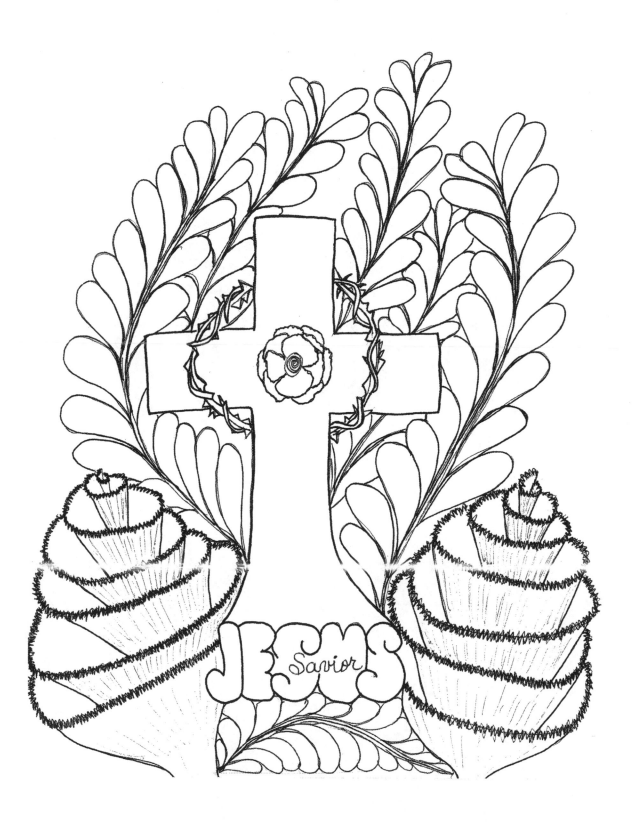

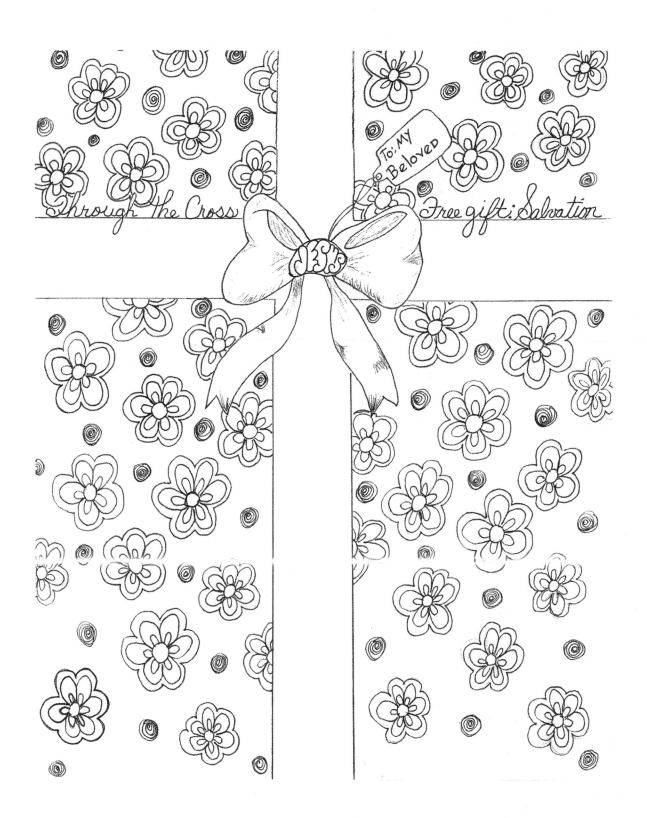

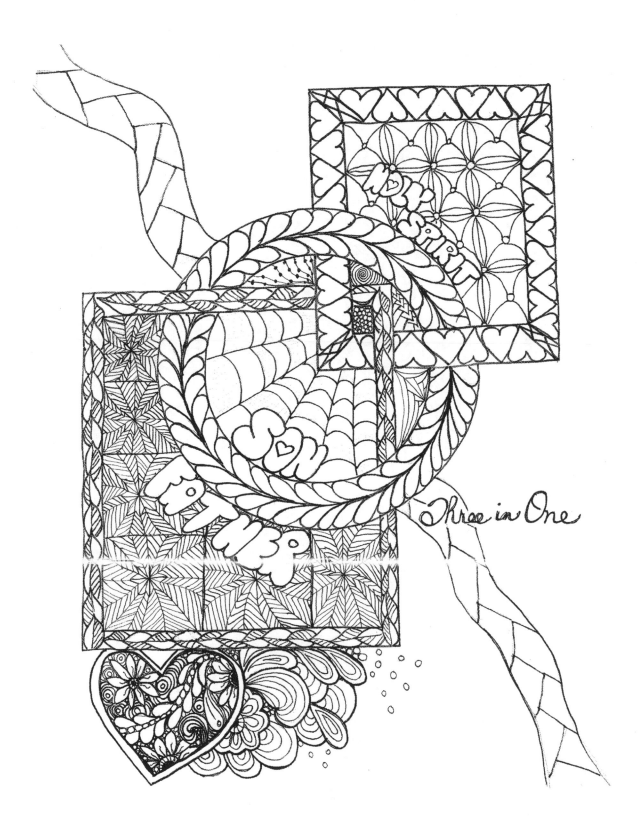

HOLY SPIRIT

SON

FATHER

Three in One

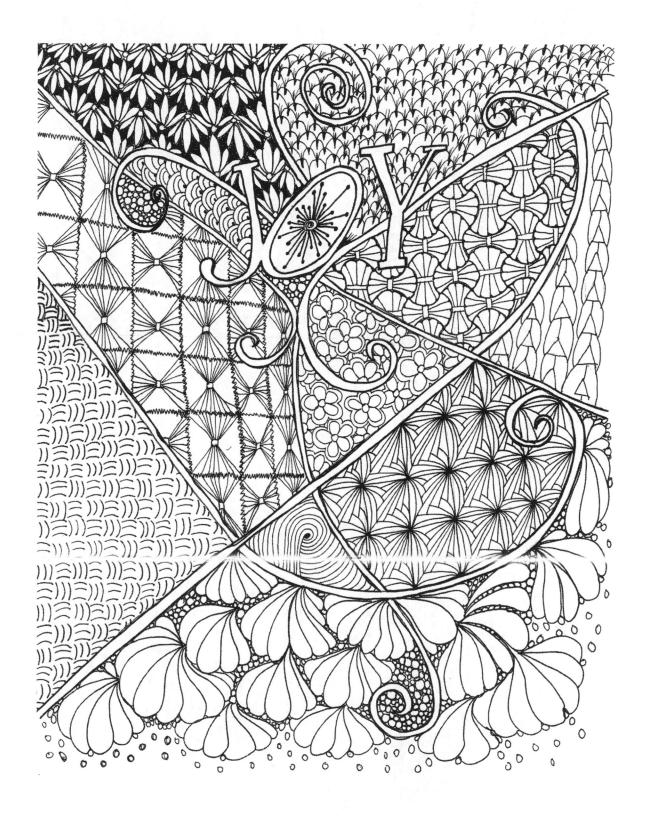

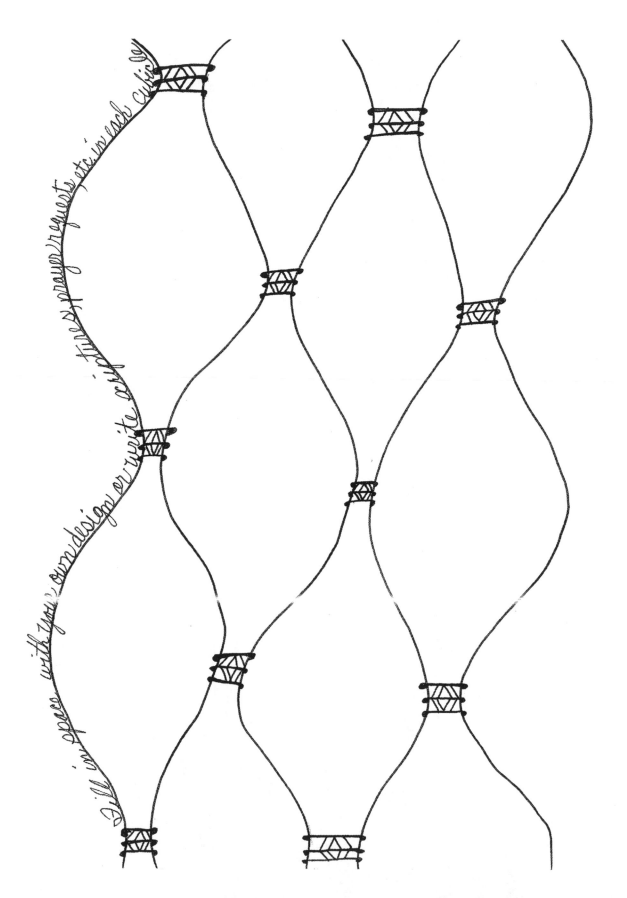

Fill in spaces with your own design or write scriptures/prayer/requests etc. in each cubicle

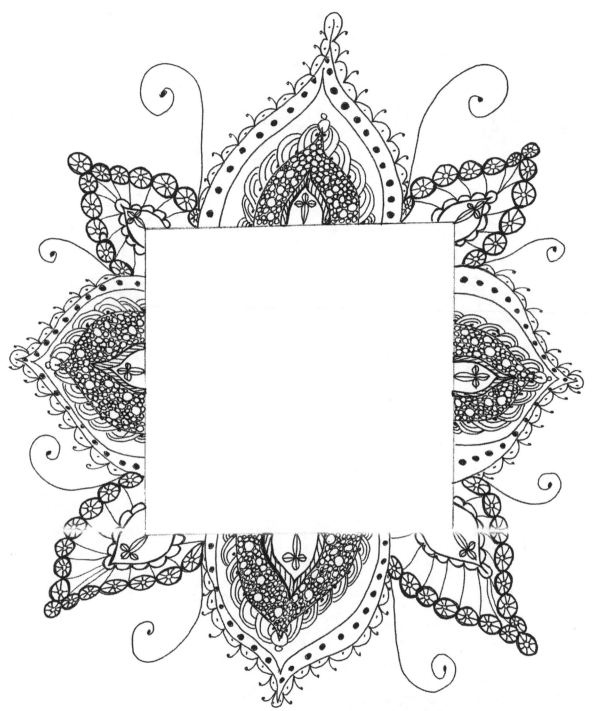

Draw your own picture to Him or write your gratitude to Him in the frame. Color and add embellishments around it.

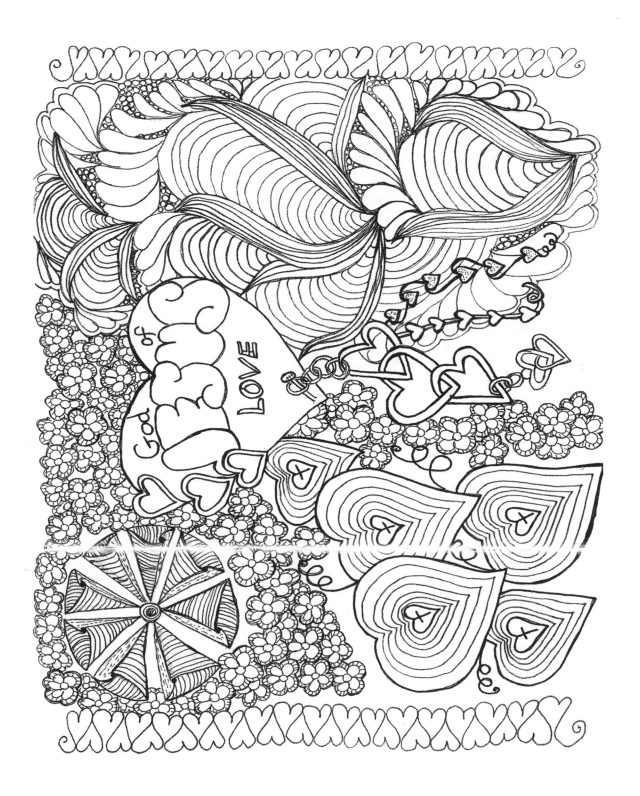

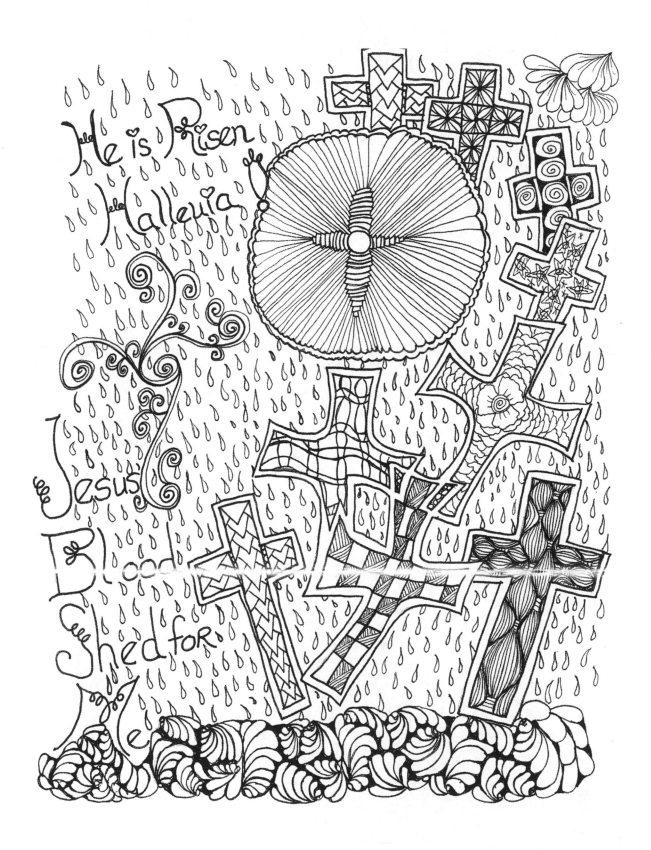

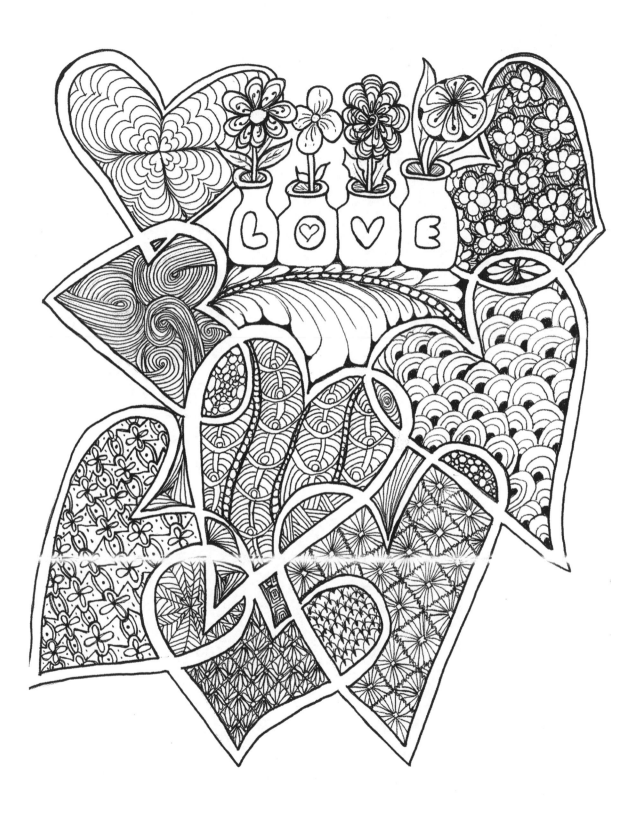

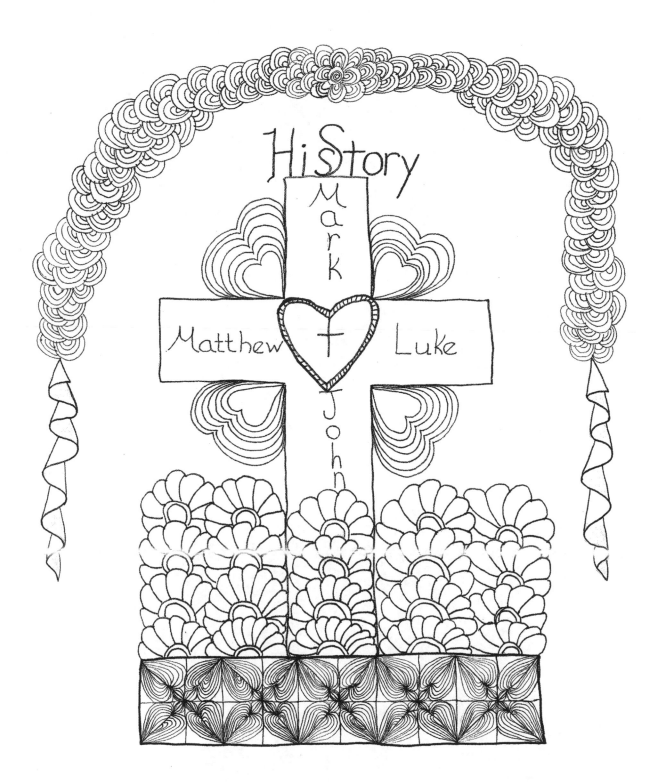

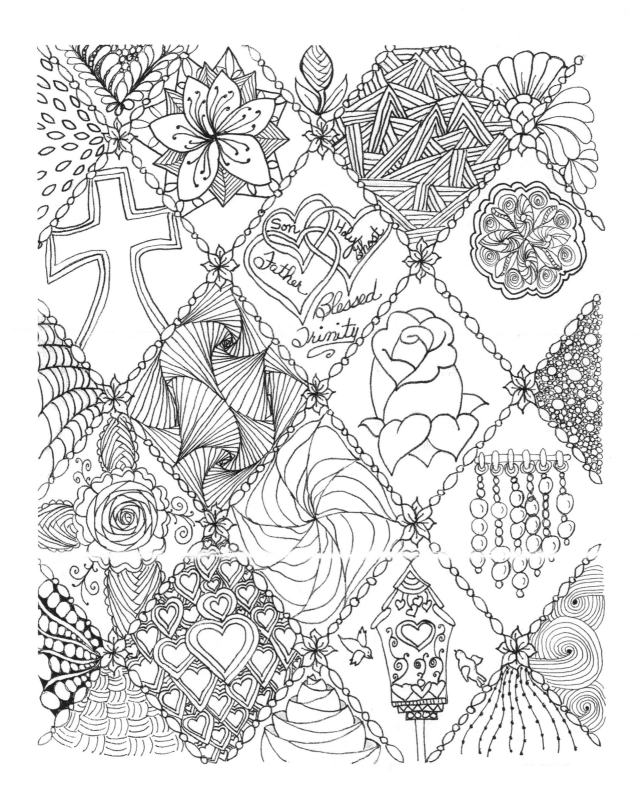

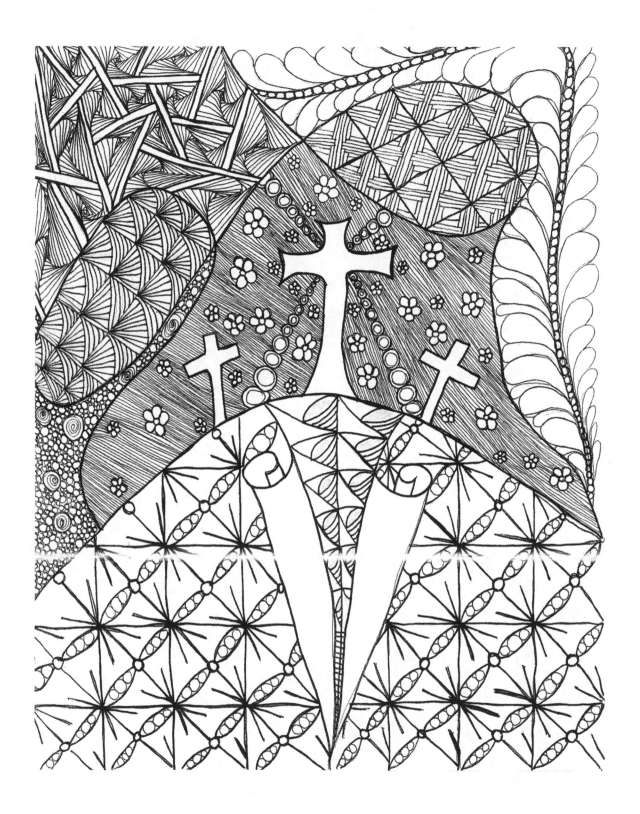

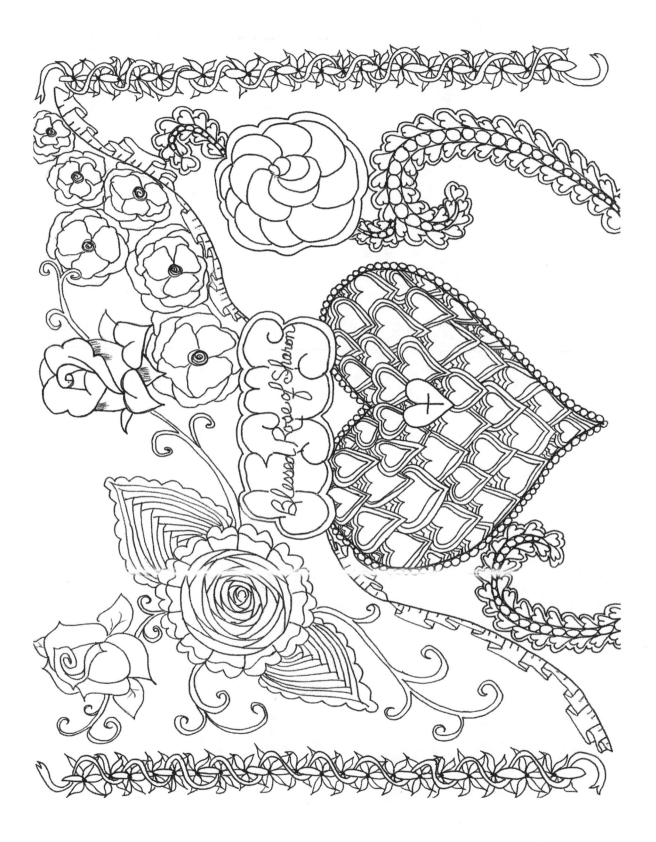

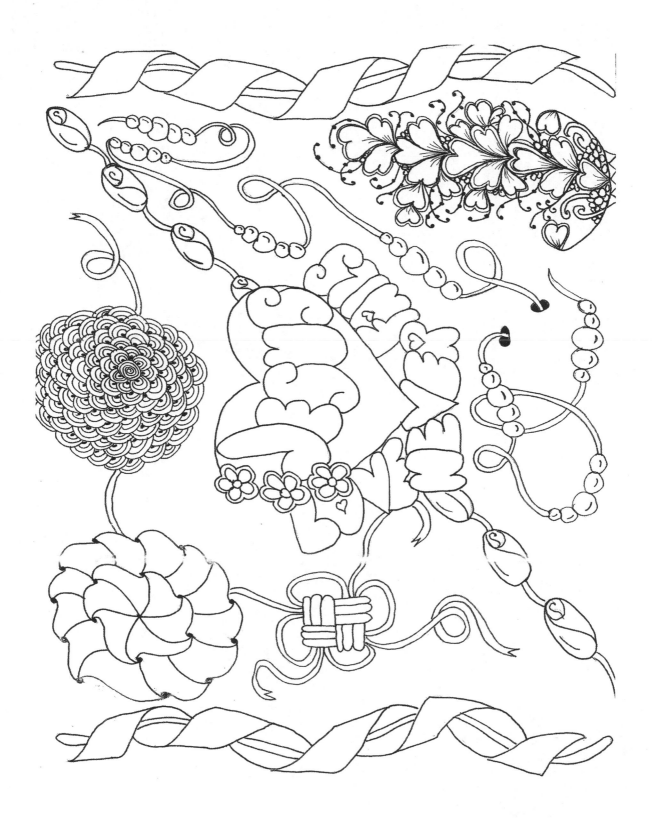

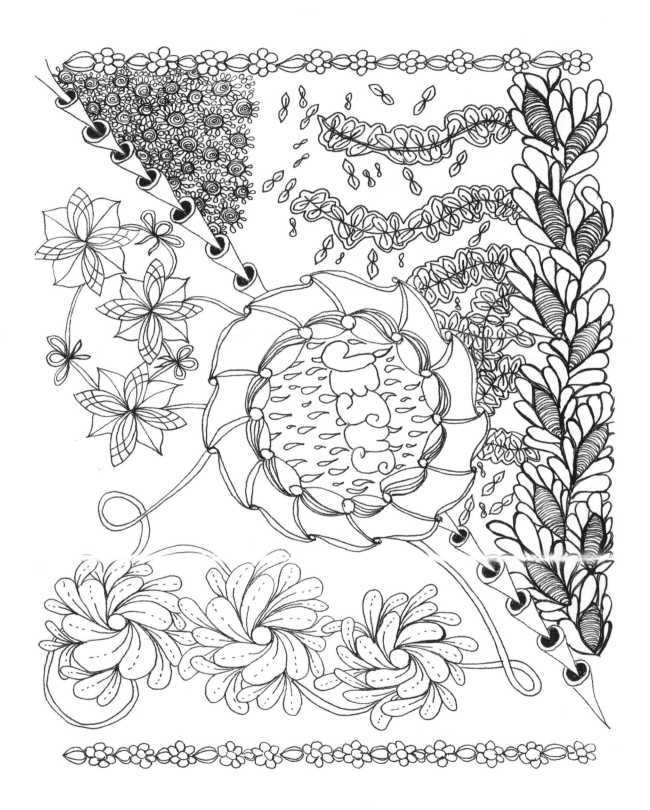

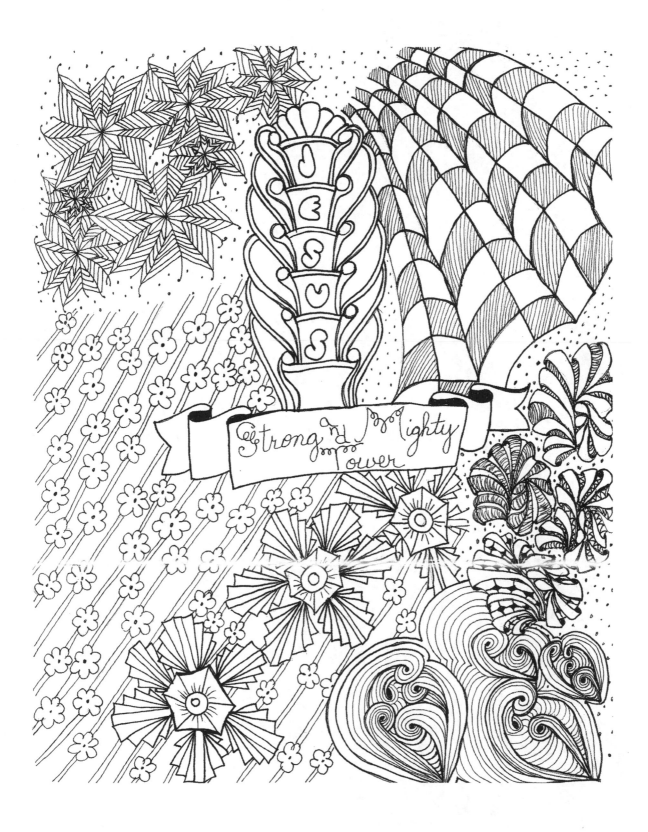

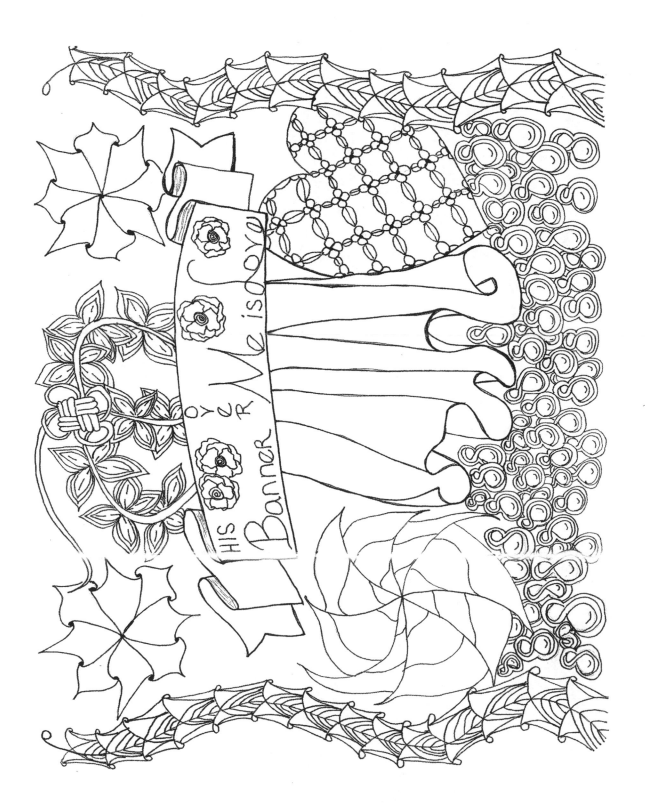

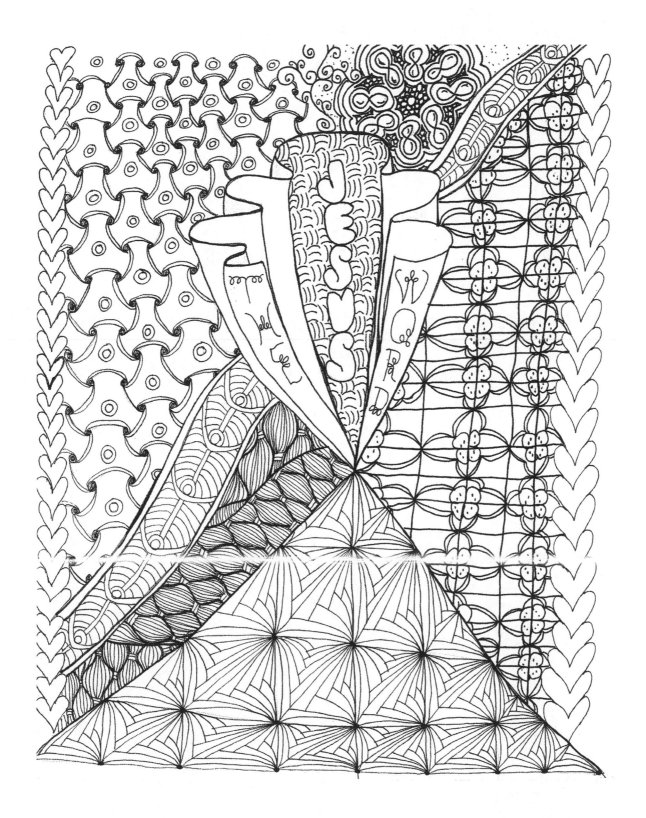

47

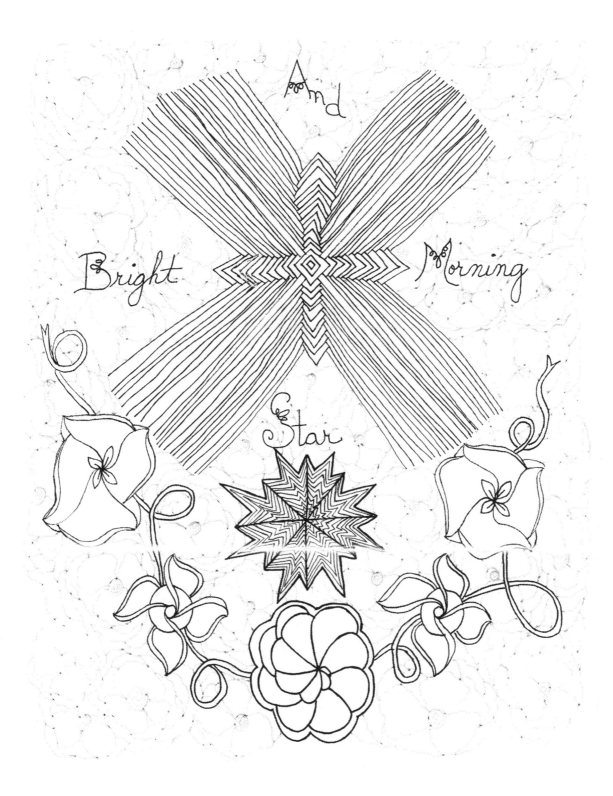

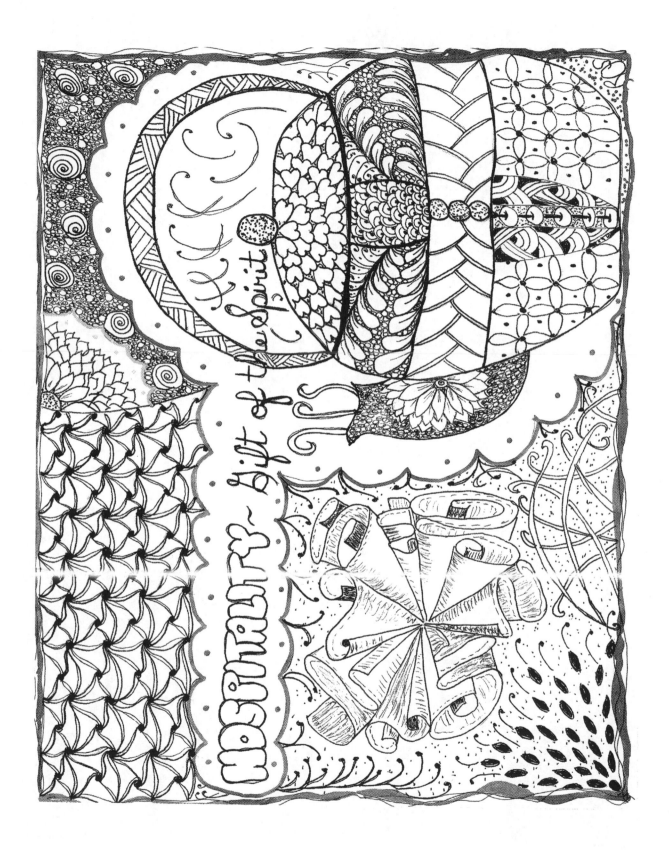

HOSPITALITY ~ gift of the Spirit

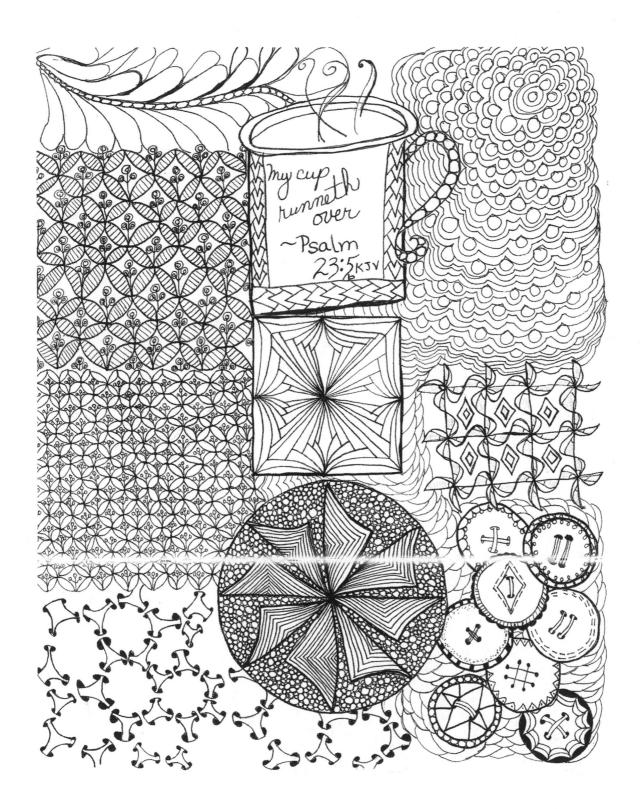

My cup
runneth
over
~Psalm
23:5 KJV

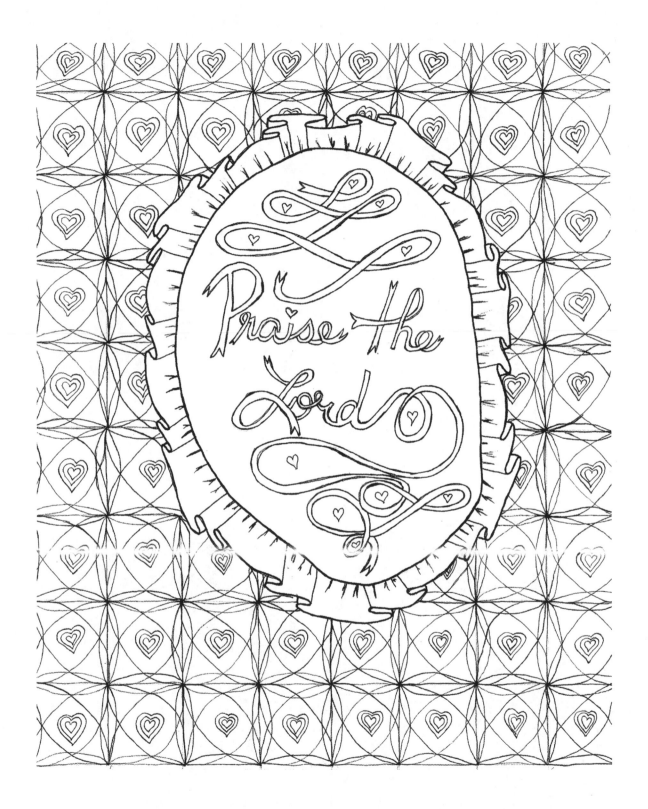

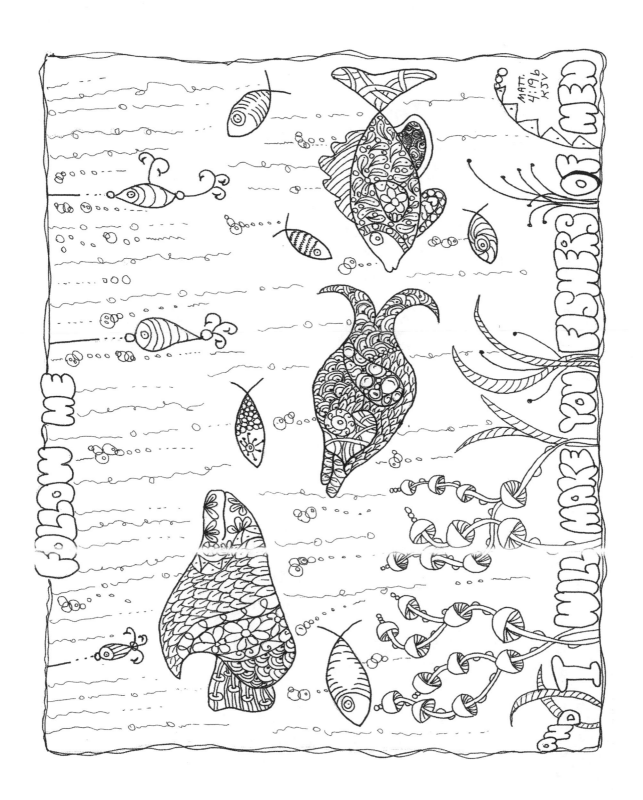

57

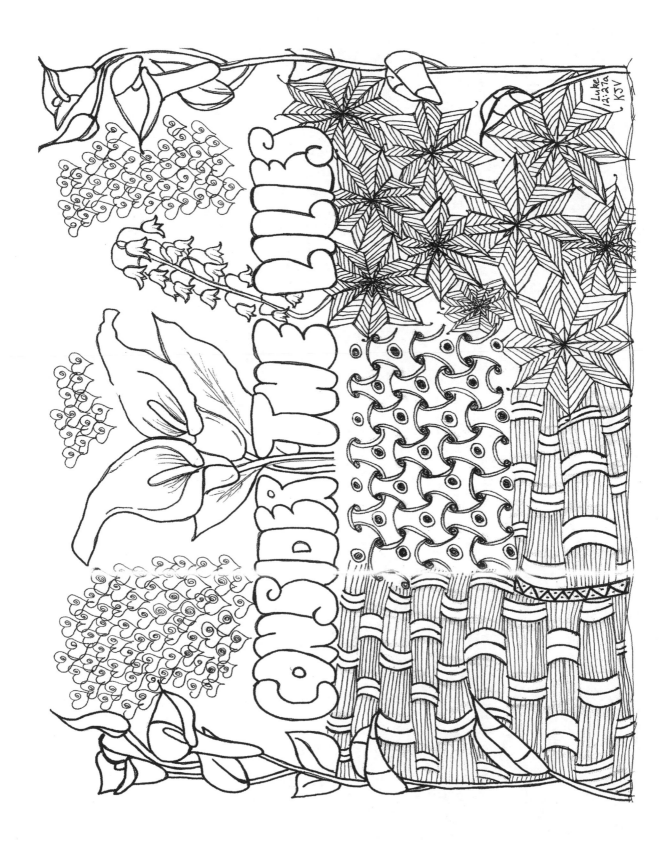

Luke
12:27a
KJV

CONSIDER THE LILIES

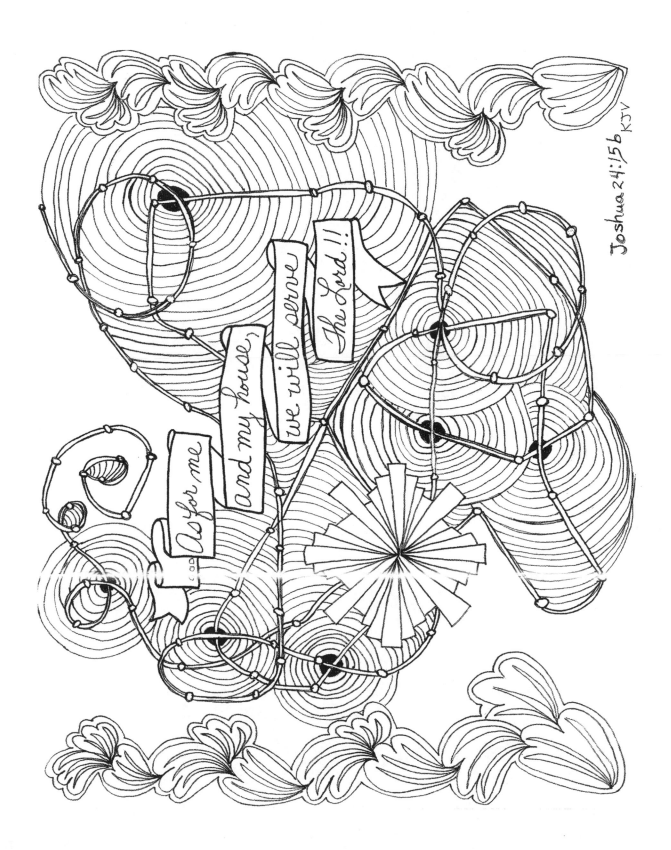

Joshua 24:15b KJV

As for me and my house, we will serve The Lord!!

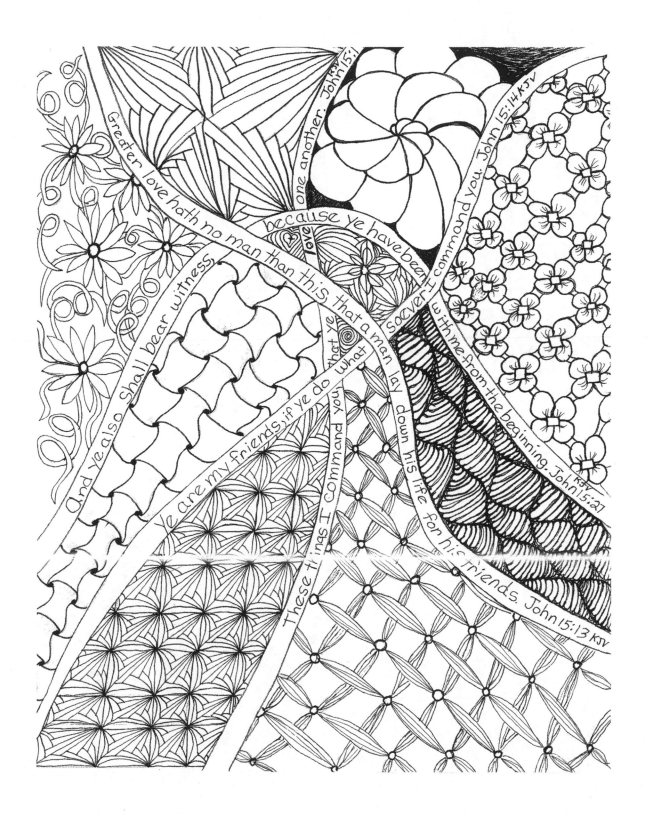

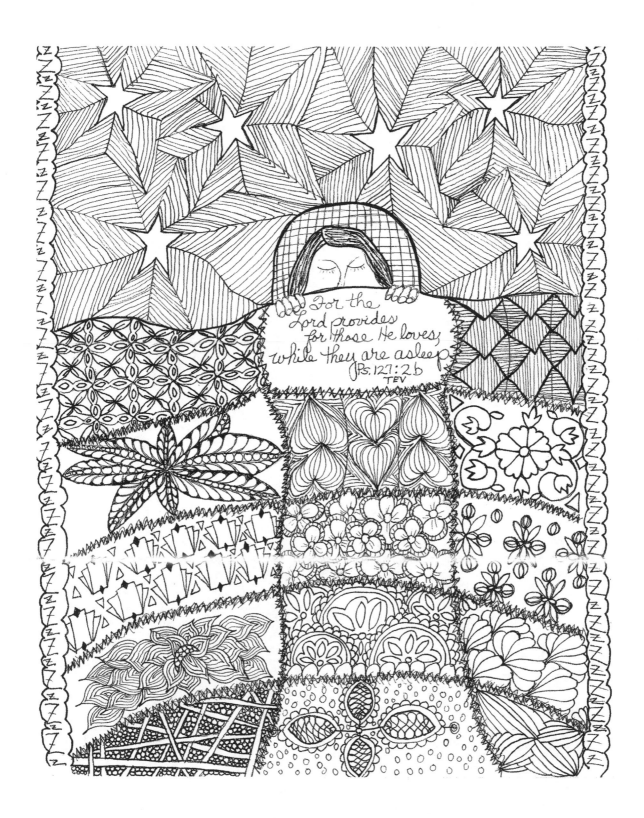

For the Lord provides for those He loves; while they are asleep. Ps. 127:2b TEV

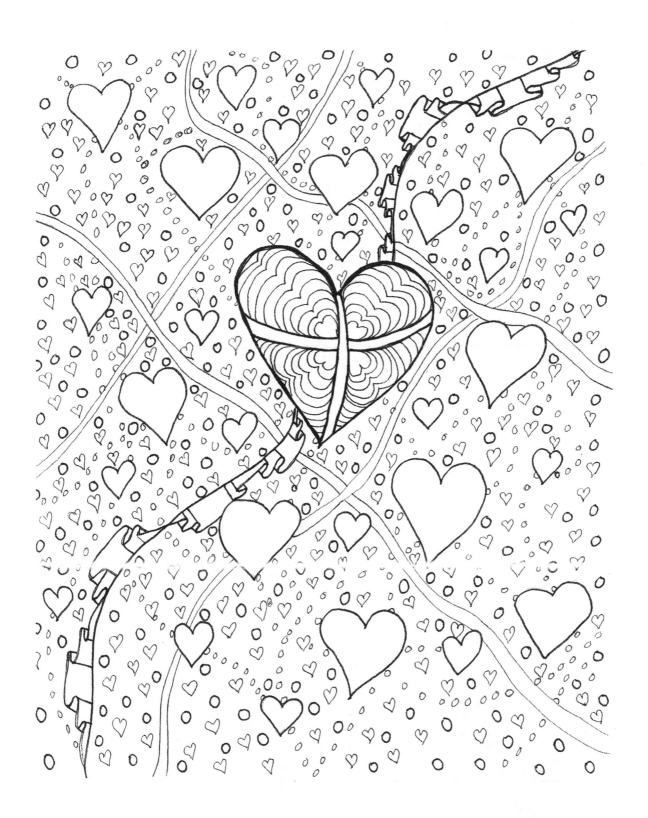

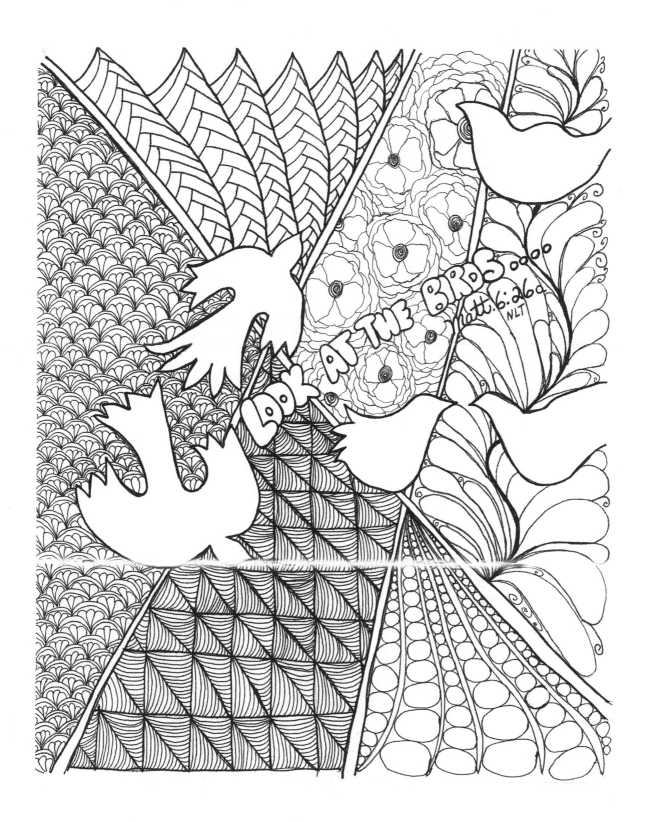

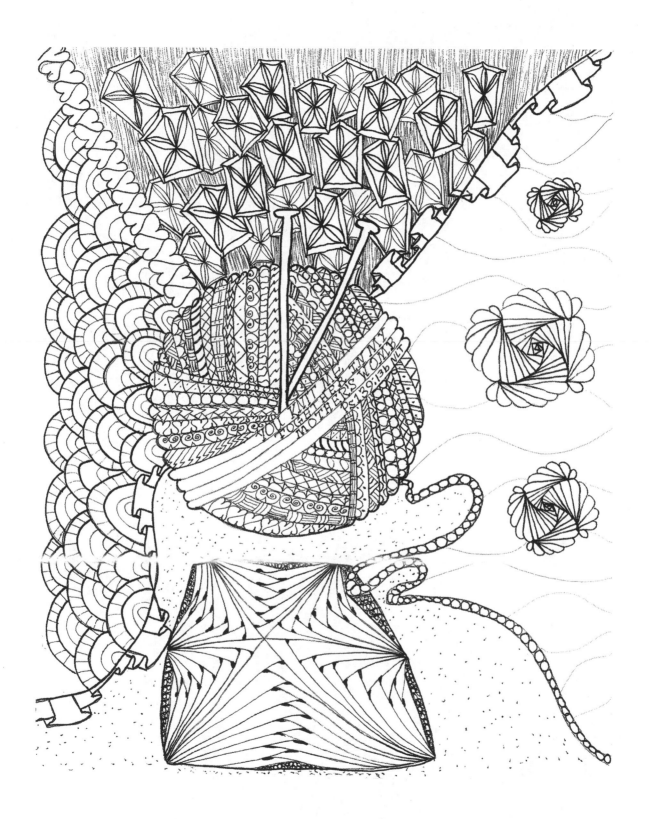

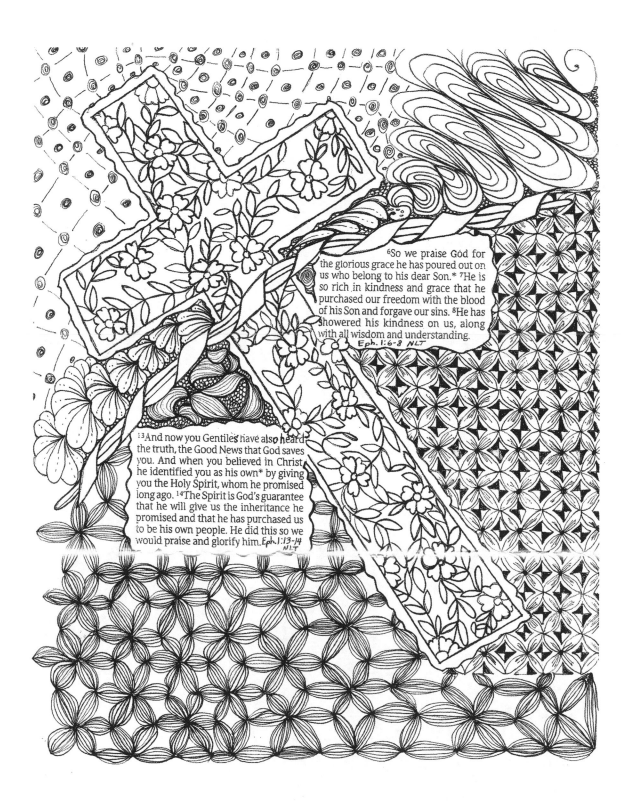

⁶So we praise God for the glorious grace he has poured out on us who belong to his dear Son.* ⁷He is so rich in kindness and grace that he purchased our freedom with the blood of his Son and forgave our sins. ⁸He has showered his kindness on us, along with all wisdom and understanding.
Eph. 1:6-8 NLT

¹³And now you Gentiles have also heard the truth, the Good News that God saves you. And when you believed in Christ, he identified you as his own* by giving you the Holy Spirit, whom he promised long ago. ¹⁴The Spirit is God's guarantee that he will give us the inheritance he promised and that he has purchased us to be his own people. He did this so we would praise and glorify him. Eph. 1:13-14 NLT

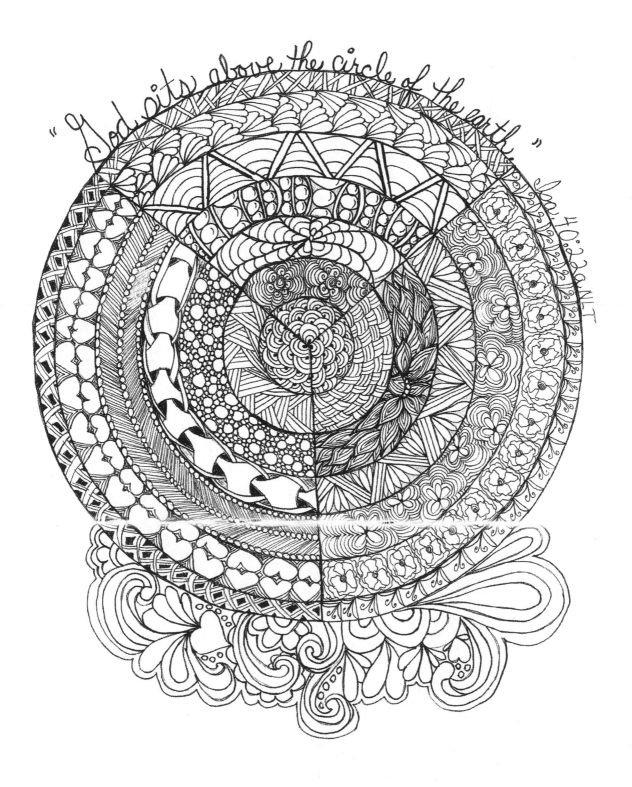

"God sits above the circle of the earth"

About the Author

Sherry loves to glorify God through the creative arts. As a former worship dancer, she has seen how people are drawn to the Gospel through the arts. Many people won't go into a church, but they will watch and be touched by Christian Creative Arts. Her love of the new art form of Zentangle inspired her pictures for this book. Sherry has known the Lord Jesus Christ as her personal Lord and Savior since 1977. It's been an awesome journey!! Sherry is a graduate of the Leadership Training Track at Elim Bible Institute. Sherry currently resides in Hagerstown, MD and is a member of Crossroads Community Church. She is mother of two sons and grandmother to six!! Sherry is currently serving as President of Hagerstown Aglow Lighthouse, which is part of Aglow International.

Printed in the United States
By Bookmasters